Etching and Intaglio Printing

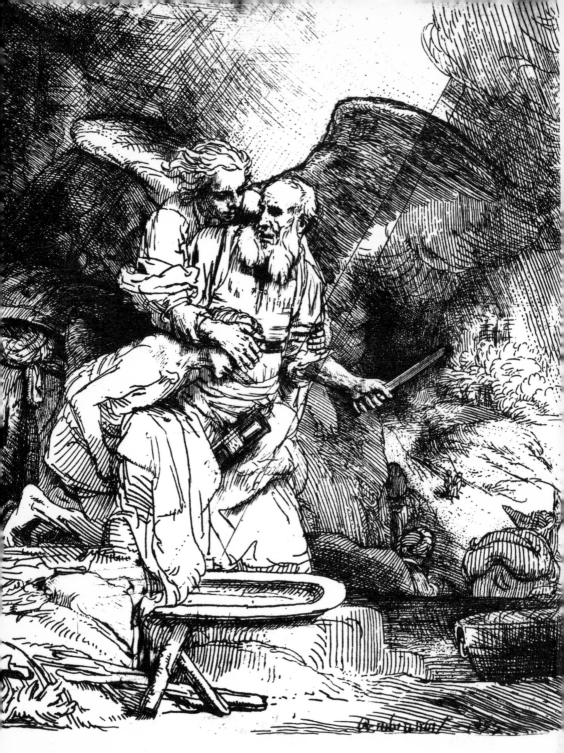

Rembrandt's etching: "Abraham's Sacrifice"

ETCHING AND INTAGLIO PRINTING

A practical guide for beginners

M J Middleton

WARD LOCK LIMITED · LONDON

ISBN 7063 1103 5

Ward Lock Limited, 116 Baker Street,
London W1M 2BB

Impreso en los Talleres de EDITORIAL FHER, S. A.
Calle Villabaso, 9.– BILBAO-ESPAÑA
PRINTED IN SPAIN

ACKNOWLEDGEMENTS

The author and publishers wish to thank Mr. Jack Coutu of Farnham School
of Art, and Mr. Dick Hart, Head of the Printmaking Department of Chelsea
School of Art, for generously providing facilities for photography; also
Mr. John Roberts for his helpful technical advice in regard to both text
and illustrations.

Designed by Bruce Thomas

CONTENTS

1 Present attitudes towards print-making

Whoever coined the phrase "come up and see my etchings" did the art of intaglio printing a great disservice from which it is only just recovering. For a long time print-making has been looked upon as the poor relation of the arts instead of as a valid creative medium in its own right. This state of affairs was brought about by two main attitudes which stem from a basic misunderstanding of what the meaning of a work of art is. Both of these have their origins in the nineteenth century.

The industrial revolution that was well under way in the nineteenth century brought with it a revolution in communications. Newspapers appeared and books became much more widely available, and because of this a knowledge and understanding of the work of artists was made available to a much larger section of the population. The revolution in communications and the resulting educational advances began to change the role of the arts. Whereas before art had been the privilege of the few who had the time and money to acquire pictures it now became something that was demanded by the educated masses of the new middle class. This automatically put pictures at a premium and created false rarity values for the original works of masters. Because of this, art became big business, with collectors buying pictures as much for their value as investments as for their intrinsic value as works of art. The gallery systems that grew up in the major art centres of the world were a party to this dissemination of false values and they had obviously to take a stand on the question of multiple prints. If a patron of a gallery bought a drawing by Rembrandt in the hope that its value would appreciate in a few years he would not have been very pleased if the market was then flooded with a large number of similar drawings done by Rembrandt on to a metal plate. The original drawing would obviously lose its rarity value and so become worth less money to all but the person interested in it as a picture alone. The print had

therefore to be discredited in some way and made to be worth less money than a drawing, even though the print might have been drawn and printed by a great master and even though it might be a better example of his work than his individual drawings. For these reasons, then, the idea that 'best is most expensive' was brought into the art world. Prints were sold cheaply and were therefore thought to be worse than individual drawings. These financial considerations were then one of the reasons for the present attitude to print-making.

The other main reason for the current attitude towards print-making is that during the nineteenth century the art of producing a fine edition of prints as an original work was to a great extent given up and printing became almost exclusively a means of cheaply reproducing the paintings of great masters. The engravers and etchers of the nineteenth century became so proficient at their craft that they could even transfer the work of a painter like Turner on to a metal plate in black and white. In fact it is said that there was a time when few houses in England were without their printed reproduction of the 'Fighting Temerere'.

With the development of both lithography and photography in the second half of the nineteenth century came the gradual decline in printing from etched or engraved metal plates. In fact intaglio printing as an art and as a craft would have been in danger of dying out altogether if it had not been for artists such as Lacourriere, Hayter and Picasso. These men, working outside the frustrating atmosphere of the English art world, revived many of the old techniques and produced many fine and exciting editions of prints. W. S. Hayter especially, while working with Lacourrier and subsequently in his own atelier in Paris, revived the old sugar—aquatint process of etching and did much to revolutionise our attitudes towards engraving. It is thanks to men like these that the road has been reopened to that exciting and beautiful world that was appreciated so highly by Rembrandt, Goya, Whistler and so many other great masters.

2 Printing methods

Having cleared up some of the more commonly held misconceptions about printing let us now consider in more detail the various kinds of print. These are most easily distinguished by the method of printing used and the material used for the original plate or block.

Firstly we have the surface print such as the linocut, woodcut or that most commonly found in schools, the potato cut. This method of making prints is the oldest recorded and perhaps the simplest. If a rectangular block of lino, wood, or potato were to be covered in black ink and then pressed on to a piece of white paper the result would be a black rectangle printed on to the paper. If, however, areas were gouged from the surface of the block they would not print on the paper and the result would be a black rectangle with areas showing through as white paper. Surface printing therefore relies upon a block being gouged away to make an image that will print in black and white. The printing is done either in a simple hand press that exerts a downward pressure or by rubbing over the paper on the block with a wooden spoon.

Secondly there is a stone or metal plate lithography. This technique can also be considered as surface printing as it relies upon ink being rolled over the surface of a stone or metal plate, but it differs from the above technique in the way that the original image is made and in the press that is used. For lithography, zinc plates or blocks of stone that are sensitive to grease are needed. The image is drawn on to the plate with a greasy crayon or ink. After this the plate is desensitised with chemicals. The grease or ink of the original drawing rejects these chemicals and the result is a plate that is only sensitive to ink where the original drawing was done. The plate is then thoroughly cleaned and rolled over with greasy ink that only sticks on the sensitive areas. The image is then transferred on to paper in a specially constructed

press that exerts great pressure.

Thirdly there is the seriograph or silk-screen method of printing. This technique prints an image by forcing ink through a screen of stretched material (usually silk, organdie or very fine wire mesh) on to which a stencil has been fixed. The seriograph has the advantage of not requiring a press but it is limited by not easily lending itself to anything but the printing of very flat areas of tone. Flat areas, lines and finely graduated tone can, on the other hand, be easily made by both lithography and our final category, with which this book is primarily concerned, intaglio printing.

Intaglio printing, which incorporates etching, aquatint, mezzotint, engraving and drypoint engraving, takes its name from the Italian 'tagliare' which means 'to cut'. This method of printing therefore relies upon an image being cut (or eaten with acid) into a metal plate. The plate is then covered with ink and subsequently cleaned leaving ink only in the cut areas. The plate and paper are then run through a press under great pressure so that the paper is forced into the cavities in the plate thus picking up the ink. The result, unlike any of the other techniques, is an image that is seemingly built of ink in relief on the paper. Although there are many different ways of making an image on a metal plate the kind of printing that produces an image in low relief is exclusive to intaglio printing and is its main distinguishing characteristic.

3 Etching

The word etching is derived from the German 'atzen' which literally means 'to make to eat'. Etching is, therefore, a method of making a printing plate by using acid to eat away areas of metal. A metal plate is covered with a thin film of acid resistant ground which is then removed in places, using a pointed tool, leaving an image drawn through the ground. The plate is then submerged in dilute acid which eats into the plate in the places where the ground has been removed, leaving a plate with an image eaten into it. The next step is to fill all the cavities in the plate with ink. This is done by covering the plate with ink and then carefully wiping clean the areas that do not need ink. During the wiping the cavities will catch the ink while the surface areas will be wiped clean. The plate is then positioned on the bed of a specially constructed press and is ready for printing.

As the paper has to be forced into the cavities in the plate it must be supple. This suppleness is achieved by soaking the paper for long enough to remove any size that might have been used in its manufacture. This can take anything from five minutes to a number of hours, depending upon the amount of size in the paper. Once the paper has been adequately dampened it is laid over the plate and the two are run through the press under great pressure. The pressure of the press forces the paper into the cavities in the plate and the ink is picked up.

In the following sections I shall describe the process stage by stage, from choosing the right plate to caring for the finished prints.

The plate

Many different types of metal plate can be used for etching but it is usual practice nowadays to use either zinc, copper or iron.

Zinc is quite cheap and can be bought from most dealers in ready cut and polished sheets. It can be used unpolished but this makes for added difficulties and is therefore not advisable for the beginner. Zinc is bitten by acid fairly rapidly and will stand up to a great deal of deep biting but it is a soft metal and therefore deteriorates fairly quickly under the pressure of the press. Because of this it is not very useful for small and intricate work, but for bold designs in black and white it is ideal. Another drawback to the use of zinc is that it reacts with most coloured inks causing them to turn yellow. It is therefore only good for printing in black ink.

Iron is the cheapest of the metals most commonly used, and can be bought from almost any local hardware store, whereas both the other two metals can usually only be found in stores dealing exclusively in etching supplies. Unlike zinc, iron bites slowly and extremely evenly, and being a hard metal it will stand up to a great deal of printing. It is therefore good for use with intricate designs, but has two major disadvantages. Firstly it must be polished before it can be used. This can only be done with the aid of some kind of mechanical buffer, and even then it takes a long time and much hard physical work. Secondly it corrodes rapidly and is therefore difficult to keep. The only way to keep an iron plate rust free is to cover it in a layer of Vaseline or similar thick grease. This necessity for continuous covering and cleaning of the plate adds yet more time to an already lengthy process.

Copper is the most expensive of the three metals but it has many advantages. It not only bites slowly and accurately, but being a relatively hard metal it will stand up to a lot of printing. It can also be used with all types of coloured inks, except yellow, without the risk of discoloration. Finally it is the only one of the three metals that is well suited for direct engraving (see sections on burin and drypoint engraving).

As the presence of grease will interfere with the laying of the ground and cause foul and uneven biting, the plate must be thoroughly cleaned before work on the etching is begun. The presence of grease can easily be seen by placing the plate under a gently flowing tap. If there is any grease on the plate the water will run around it in rivulets. To clean it off the plate must be briskly rubbed with a cloth and a mixture of dilute ammonia and french chalk. When the plate is clean and completely free of grease, water should run across it in an unimpeded sheet. Detergents can also be used for removing grease but they never seem to be quite as efficient as ammonia.

With the plate sparkling, clean and dry it is ready for the next stage in the operations; the laying of an acid resistant ground.

Laying the ground

Two different types of ground are in common use today: a soft and a hard ground. The soft ground, as its name implies, is soft and sticky and will stick to any surface that is pressed against it. The hard ground on the other hand, is hard and can only be removed by being scraped off with a hard pointed tool. Both types of ground are made of a mixture of bitumen, beeswax and resin and can be bought in block form from any etching suppliers. There are on the market liquid grounds, but they tend to crack during drawing. They are also easily wasted and therefore tend to be rather expensive. It is possible to mix one's own grounds, but this is a tricky job and it is therefore advisable for the beginner to stick to the reputable ready-made brands.

Various pieces of special equipment will be needed for laying the ground, the first of these being a 'heat box'. This is usually an iron platform that stands on legs over a small gas ring. If the plate that is being grounded is fairly small an ordinary hot plate on a kitchen stove will do just as well. The plate is laid on the heat box and evenly heated until it is just too hot to touch. When it has reached this heat a block of ground is dabbed all over it. The heat causes the ground to melt and form patches all over the plate. These patches are then rolled out with a soft, leather-covered roller until the plate is covered with a thin and even film of ground. Care must be taken not to lay too much ground and to lay it evenly as thick patches are liable to crack and splinter when the drawing is done. Sufficient ground has been laid when the plate is covered with an even, transparent, golden-brown layer. Opaque, dark-brown patches indicate that too much ground has been put down. These patches will need to be removed with a small piece of rag and the whole surface will need more rolling. Care must also be taken not to overheat the plate. If this happens the ground will begin to smoke and smell and will be ruined. In this event the only course of action is to thoroughly clean the plate with turpentine followed by dilute ammonia and to lay a fresh ground at a lower temperature.

An alternative way of laying a ground is with a 'dabber'. The dabber is a wooden instrument rather like a flattened pestle that is covered

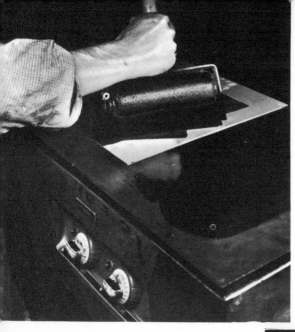

2 Cross section of the construction of a dabber

Kid Leather — Wood

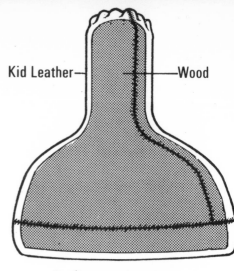

1 A hard ground rolled out over the plate—heated on the heat-box

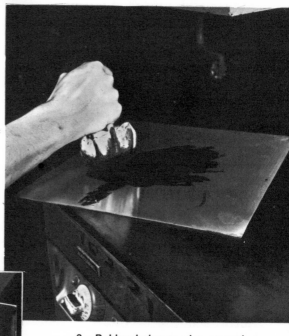

3 Dabber being used to spread an even soft ground over the plate

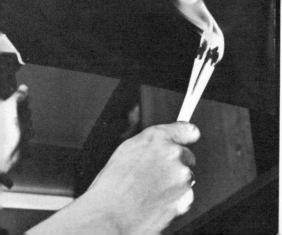

4 Smoking the plate to darken and harden it

with kid leather. Between the wood and leather are placed some pieces of broken up ground which melt when the leather comes into contact with the hot plate. When the ground melts, it in theory runs through the leather and covers the plate with a thin, even layer. I have always found that using a dabber alone can cause the ground to be laid patchily and I would not therefore advise its use for a beginner.

Perhaps the most effective method of laying a ground is to mix both the dabber and the roller techniques. When the plate has been heated it can be dabbed all over with the dabber and the resulting deposit of ground can then be rolled out with the roller. In this way one can control very effectively the rate at which the ground is deposited, thus safeguarding against laying too much.

The rollers and dabbers that have been used need no cleaning but must be kept hanging up free of all dirt and dust. They should also be used exclusively for one type of ground. A roller that has been used for laying a soft ground should not be used for a hard ground and vice versa.

Once the plate has been grounded to your satisfaction (a stage that will soon be learnt by practice), it is ready for smoking if it has a hard ground, or for drawing if it has a soft ground.

Smoking the plate

There are two reasons for smoking a plate. Firstly it makes any drawing done subsequently show up with greater contrast. Secondly it helps to harden the ground, thus improving its acid resistant properties. Because of this hardening effect, smoking should only be used with a hard ground and never with a soft ground.

Smoking is done while the plate is still warm from the grounding process or after very gentle re-heating. This is because a ground that is slightly molten will absorb the smoke well. The plate is held with the ground facing downwards in a hand vice or with a small piece of folded card. Care should be taken not to grip the plate too tightly as this might cause some of the ground to be lifted. A candle, or still better, a twist of three or four tapers is then lit and passed to and fro across the grounded side of the plate at a distance of about one inch. The smoke from the tapers will mix with the ground, turning it black. The tapers should be kept moving all the time, and should never be closer than one inch to the plate. If these two points are not

carefully watched the ground is likely to overheat and be ruined.

When the plate is uniformly blackened, it can be left to cool, when it will be ready at last for the drawing.

Drawing on the plate

As every artist will know best how he can express himself, it would be useless for me to try to suggest what sort of print and therefore what sort of drawing should be made. Every individual will soon learn by experience and experiment which of the available techniques are best suited to his own visual ideas. What I can do, however, is to describe the major possibilities at his disposal and to point out that the lines and tones that are produced by printing from a metal plate are nothing like those of any other medium. It would be pointless, therefore, to use etching merely as a means of reproducing work done in other fields.

As the drawing techniques are different for hard and soft grounds I shall deal with each individually. The one common requisite for both grounds, however, is that they should be thoroughly cool before the drawing is commenced.

1 Various standard and improvised tools for drawing into a hard ground

2 Making a drawing on tissue over a soft ground

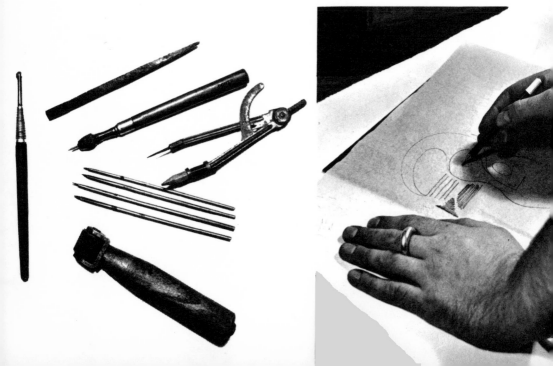

A HARD GROUND: Drawing can be done into a hard ground with any pointed instrument that will lift the ground without scratching the plate. Tools I have seen used have ranged from nappy-pins to screwdrivers. If the tool that you select is sharp, such as a pin or nail, it will need to be slightly blunted on a stone before it is used.

The two main areas for exploitation in a simple hard ground etching are the 'etched line' and the 'open bite'. The etched line, as it suggests, is simply a line etched into a plate. A thin pointed tool will make a thin line and a thick tool will make a thicker line. When drawing a line into a ground, care should be taken to remove all the ground from the line. If yellow smears are left showing along the line it means that some ground remains. These smears will, if not removed by re-drawing, cause the acid to bite unevenly, which will in turn cause the printed line to be jagged or broken.

One point well worth remembering is that a plate, when printed, gives a reversed image. Any lettering or similar image must therefore be drawn on to the plate in reverse.

Apart from the simple etched line there is the 'open bite'. Open biting is the technique of removing whole areas of ground from the plate and allowing the acid to bite evenly over the whole of the exposed

3 Typical lines produced by drawing into a hard ground

4 Typical lines produced by drawing into a soft ground

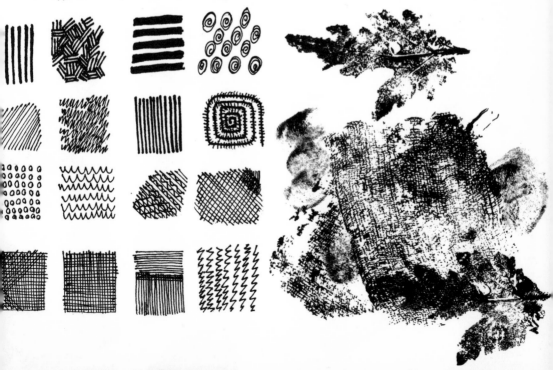

area. The printed result of this treatment can, if carefully done, be extremely exciting.

There is much room for experiment into the type of marks that can be made, and into the kinds of tools that may be used. For instance, an area of dark tone can be made by running a 'roulette' (see section on mezzotint) over the hard ground. The roulette will puncture the ground with a mass of tiny holes that will, after biting, hold ink and print as dense black tone. There are also many different kinds of pen nib on the market nowadays, some with multiple heads. If first blunted on a stone, these can be used to produce a variety of interesting effects.

A SOFT GROUND: Once the soft ground has been laid in exactly the same way as was the hard ground, but with a different roller, it is ready for the drawing. The drawing can be made in a number of different ways and with many different tools. Perhaps the simplest way of making an image is to draw directly into the ground with a fairly soft pencil. Lines made in this way will print with an attractive, soft, feathery quality. Another way of producing an image, much favoured by artists of the last century, is to draw on to a piece of thin tissue paper laid over the plate. The pressure of the pencil will be enough to cause the ground to adhere to the paper where the lines have been drawn. This method has two useful advantages. Firstly it gives the beginner who is perhaps well versed in drawing but who has never drawn into a plate before added confidence. In fact a drawing can be done on tissue paper and subsequently traced over the plate only after correction. In this way mistakes can be easily avoided. Secondly paper over the plate will keep the hand from coming into contact with the ground which might, if it did occur, cause some of the ground to be lifted. It is in fact useful to have a piece of clean paper handy whenever drawing into either a soft or hard ground in order to protect it. Another way of protecting the ground that is sometimes used is to stick a piece of shiny elastoplast over the side of the hand that is likely to come into contact with the plate when drawing.

The stickiness of the soft ground also allows for the making of many exciting textures. Almost any flat textured surface such as scrim, sandpaper or lace can be laid over the ground and pressed down firmly. The ground will stick to the material leaving the texture

reproduced exactly on the plate. Scraping, wiping and fingering are all other possible ways of making interesting textures. Only time and experiment can reveal all the possibilities.

Correcting the drawing

It is likely that before the plate is ready for biting in the acid it will be necessary to make some alterations to the drawing. You may decide that some of the lines and areas that you have drawn will after all not be needed. These are easily removed by painting them out with 'stop-out' varnish. The most commonly used stop-out varnish is made of a mixture of asphaltum and turpentine and is sold by most etching suppliers under the name of 'Rhind's Stop-out Varnish'. This varnish does, however, take about an hour to dry even though it is sold as a quick drying solution. If speed is required a perfectly adequate stop-out varnish can be made by mixing shellac with methylated spirits. This mixture should take no more than five minutes to dry out but it is less resistant to acid than is Rhind's stop-out and should therefore be watched carefully when it is in the acid, and quickly removed at the first signs of deterioration.

Before the plate is finally ready for biting it is necessary to paint out both its back and edges with stop-out. If this is not done the acid will simply bite into the plate at the edges and from beneath, and ruin all the hard work so far done.

With the drawing finished and the stop-out on both the edges and the back dry, you are ready to begin biting in the acid.

The acids

Two types of acid are in common use for etching, both nitric and hydrochloric.

NITRIC ACID: Nitric acid can be used for biting all types of plate but different strengths are called for in each case. For copper and iron plates an acid solution must be made up of two parts of acid mixed with three parts of water. For zinc plates the mixture should be a little weaker: one part of acid mixed with three parts of water.

Nitric acid is usually sold in bottles at forty per cent strength and the above mixtures allow for this. If the acid that you buy is of a different strength, the mixtures will have to be adjusted accordingly.

Nitric acid reacts rapidly with most metals and bites downwards into the plate fairly quickly. It also tends to eat the plate away sideways, and is therefore not very successful if used for etching an intricate plate with many lines drawn close together. For open biting and plates that rely upon bold areas of tone it is, however, ideal.

HYDROCHLORIC ACID: Hydrochloric acid, on the other hand, bites slowly and is much less likely to bite sideways under the ground. It is therefore an excellent acid to use with a plate made up of complicated lines such as a cross-hatched drawing. It is, however, slightly more complicated to prepare for use than is nitric acid.

To prepare hydrochloric acid for etching first boil four parts of potassium chlorate in a little water, and when it is completely dissolved, leave it to cool. Add the cooled solution to seventy parts of water, and then add the resulting solution to twenty parts of acid. The mixture should now be ready for use with any metal plate.

I am sure that there is no need to stress the care that is needed when dealing with these potentially dangerous acids. Even so, the following points are worth remembering:

1. Always use glass containers when dealing with acid, or else containers that are specially made for the job. Any improvised container is likely to be eaten away and could cause nasty accidents.

2. When acid is mixed with water a chemical reaction occurs which generates heat. Although the heat generated is not very great it can sometimes be enough to crack the glass container used for mixing. It is always a good idea, therefore, to work at a sink when handling acids.

3. If the container does crack during mixing, let the acid run away down the sink, but be sure to keep the tap running all the time. In this way any spilt acid will be diluted to a safe strength before it has had time to do any damage to the pipes. This precaution is well worth taking as water-rates are less expensive than new drainage systems!

4. When mixing acids, always add acid to water and never water to acid. This will ensure that dangerous, undiluted acid is never anywhere except in the container in which it is sold, which will obviously minimise the likelihood of accidents occurring.

None of the acids, once they are mixed to the above solutions, is so strong that you cannot safely put your hands in it, but if you do, always wash them immediately. Diluting the acid does not stop its ability to burn, it only slows the process down. It is also important

to thoroughly wash the plate when it is removed from the acid. If traces of acid, however dilute, are left on the plate, they will carry on biting almost indefinitely, thus ruining the surface and wasting all your hard work.

And finally, acid, even diluted, will harm all kinds of fabric. If it is spilt on clothing it should be cleaned off immediately with a very wet rag or better still, a wet sponge.

Once the acid has been mixed to the required strength pour it carefully into an 'acid bath'. Acid baths are low-sided trays made of acid resistant material, sold in many different sizes by all etching suppliers. I have seen baths improvised with sheets of glass and Plasticine walls, but this is very dangerous and almost certain to end in disaster. Although acid baths are fairly expensive it is dangerous and false economy to try to dispense with them.

Once the acid has been mixed and safely poured into the acid bath, you are ready to bite the plate.

Biting the plate

After making sure that the stop-out varnish on the sides and back of the plate is dry, place the plate face upwards in the acid bath.

Soon the lines and areas of the plate from which the ground has been removed will become covered with a mass of tiny bubbles. This shows that a reaction is taking place and that the acid is doing its job. Where there are large areas of open biting the plate may bubble very forcibly and give off yellowish fumes. These fumes are corrosive and should therefore not be inhaled. In order to see when the plate has been bitten enough and to ensure that the bubbles do not impair regular biting, brush the bubbles away as they appear. The best tool for this job is a simple feather, which can be kept handy at all times and easily replaced. Care must be taken not to attack the bubbles so heavily as to dislodge the ground. A gentle sweeping motion is all that is required.

Knowing when the plate has been bitten enough is a difficult task that can only be mastered with time and experience. It is, however, much better to underestimate the time in the acid, as it is much easier to re-bite lines that are too shallow before removing the ground than it is to lessen the depth of overbitten lines.

Different depths of tone can be achieved by biting lines to different

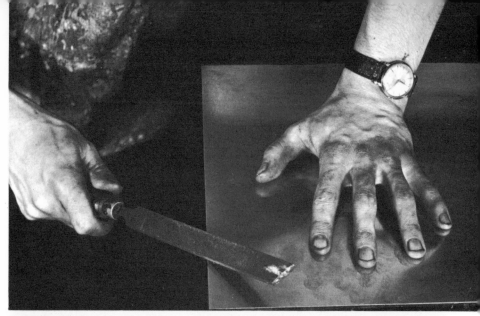

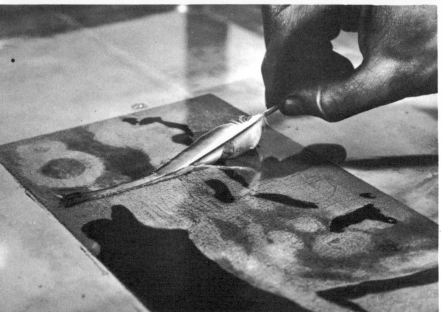

1 Filing the edges of the plate to prevent the paper tearing

2 Removing bubbles from the plate with a feather

depths. A very shallow line will print as a much lighter tone than a deeply etched line. To create these different tonal effects the plate can be removed periodically from the acid and the shallow lines stopped out. Each time the plate is removed from the acid it must be washed in water and dried. If this is done with care none of the existing ground and stop-out will come off. When the plate is dry those lines that are to be shallow can be covered with stop-out, and once the stop-out is dry the plate can be returned to the acid. This process can be repeated as many times as are necessary.

Once all the biting is finished and the plate is removed from the acid, it must once again be thoroughly washed and dried. To speed up the drying process it is useful to invest in a number of sheets of blotting paper. Once all the acid has been removed, clean the plate of all the stop-out and ground. The ground can be removed with turpentine and the stop-out with methylated spirits.

Under the pressure of the press the sharp edges of the plate might not only tear the paper but might also damage the press. To prevent this damage the edges of the plate must be filed down. Hold the plate firmly on a flat surface such as a table top with its edge protruding slightly over the edge of the table. Run a small file along the edge until a forty-five degree bevel has been made. The file should be used with a regular sweeping motion with care being taken not to stop it along the edge of the plate. If the file stops along the plate's edge or only part of the edge is filed at a time the result will be an uneven edge that will not only look messy when printed but may also harm the paper and press.

Once all four edges of the plate are bevelled to a level forty-five degrees, polish it with a rag and a little of the sort of metal polish that can be bought in any hardware store. When the plate is completely clean and sparkling it is ready for inking.

The paper

As inking the plate is a fairly messy process it is best to select and prepare the paper in advance. Almost any kind of paper is usable so long as it can be evenly dampened without excessive cockling. Size is used in the manufacture of almost all papers to give them firmness and weight. If left in the paper, size will interfere with the printing process. It therefore must be removed by soaking. To do this, place

the paper, one sheet at a time, in a sink of clean, cold water for anything from a few minutes to several hours depending upon the amount of size to be removed.

Handmade papers are most suitable for etching as they contain little or no size, have very fine surfaces and keep their whiteness for a long time. If they contain no size, they need only a little dampening with a sponge. They can, however, be very expensive. Machine-made papers, such as cartridge paper, though they may need much soaking, are perfectly adequate for almost all work, and are much less expensive than the handmade varieties.

Once the paper has been adequately soaked, remove it from the sink and lay it between sheets of blotting paper under a heavy sheet of glass, formica or similar material until it is needed for printing.

The press

For the beginner, obtaining a press will probably be a major problem. It is difficult to make an etching without the constant use of a press, and presses are expensive. There are, however, ways around this problem which I shall point out later on.

The press consists of an iron frame which supports two large wooden rollers. Between these rollers there is a metal platform or 'bed' that passes between the rollers when they are turned. Because of the pressure that is needed when etching, the rollers are usually attached to a gearing system that facilitates their turning and allows for gentle movement of the bed. The whole press looks rather like a large, glorified mangle. Supplied with the press are three blankets that are laid over the paper when printing in order to force it into the cavities in the plate. One of the blankets is made of thick felt while the other two are thinner and made of wool.

It is generally reckoned that the press used should have a bed at least twice as large as the etching. Therefore an etching with an area of twenty-four square inches will call for a press with a bed of at least eighty square inches. A press of this size (usually known as a table press for obvious reasons) costs anything between twenty and fifty pounds. An etching of any really interesting size will, however, call for a press costing anything up to one thousand pounds. I have heard of people finding cheaper, second-hand presses, but these are rare and are usually snapped up by dealers.

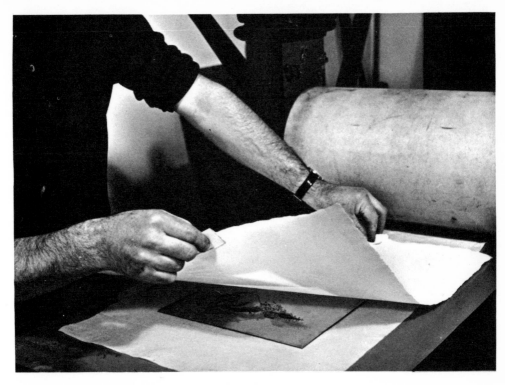

Intaglio press showing bed, rollers, blanket and plate

Do not let this deter you. There are a great many etchers today who do not have presses of their own but who use either commercial studios or art school studios. Art school studios are some of the best equipped in the country and almost every county authority has at least one. Under the auspices of local adult education institutes, they are usually open in the evenings with expert teachers on hand to help. These institutes can be joined for as little as twenty-five shillings a year. They are paid for by your rates and are yours to use.

Before using the press its pressure should be thoroughly checked for even distribution. The distribution is adjusted with two screws that are positioned above either side of the rollers. The best method of adjusting these is to tighten them as far as they will go and then to loosen them gradually half a turn at a time on either side until plate, paper and blankets will just run through without being forced out of position. If an uninked plate is run through the press with a piece of soaked paper any uneven pressure will show up on the paper as an uneven relief.

The blankets that are used are expensive and should be treated carefully. They should never be allowed to fold under the rollers, and as an added precaution they should always be removed when the press is not in use. It is a good idea to set aside a special shelf on which to keep them out of the way of acids and inks. These blankets become soiled very quickly and will therefore need regular washing in soap and warm water.

With the press adjusted properly and the paper soaked and sponged you can start printing, beginning by inking the plate.

Inking the plate

It is here that the printer's skill really begins to show, for every print of the edition must be inked identically. There are, in fact, very few printers alive today who have the skill and experience to produce large editions of exactly similar prints, but with care and attention to detail the beginner should be able to produce a fair number of identical proofs.

As you will be dealing with sticky ink that seems to have a will of its own and is intent upon spreading as far as it can, the first requisite is to be well organised, with ink, rollers and scrim all in sensible, easily accessible places.

Jigger and heat-box

Although it is not absolutely necessary, it is helpful to have a raised platform or box positioned alongside the heat-box. This raised box is known as a 'jigger' and is used to hold the plate after it has been heated ready for inking. If you are using the hot plate of a kitchen stove it is a good idea to have an old pair of leather gloves that are thin enough to allow easy handling of the plate after it has been heated, while still thick enough to protect your hands from the heat. An inking slab will also be needed. In most etching studios this is an old lithographic stone, but any thick piece of glass or perspex will do just as well.

The ink can be bought in most art shops ready mixed, but as the quality of the print depends very much upon the consistency of the ink it is always best to make it yourself. The ingredients called for are easily available and consist simply of black pigment mixed with light and heavy oil. For the beginner, a good mixture to work from is one part of 'Frankfurt black' and two parts of 'French black' ground together on the inking slab with a pestle. When the pigment has been ground to an extremely fine powder, light and heavy oil can be added in equal quantities and the whole can be mixed with a strong palette knife until it is of the required consistency. It is usually reckoned that the ink is ready when it is just thick enough to drop from the knife in large globules. Ink that is thinner than this is likely to spread and smudge during printing. Ink that is much thicker will stick to the paper during printing and cause it to tear when it is lifted from the

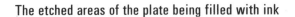

The etched areas of the plate being filled with ink

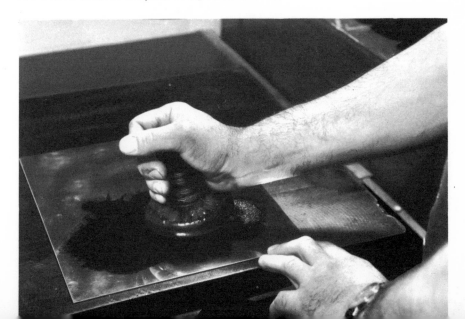

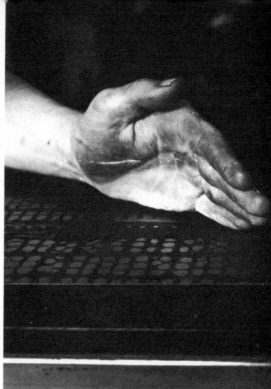

Wiping the plate first with scrim and hand finish

plate. If the ink is prepared some time before it is needed or some is left over after the printing is finished, it can be stored indefinitely in a jar of water. The water insulates it from the air, thus inhibiting the drying process. It is better, however, to mix only as much ink as is immediately needed, for no matter how well it is looked after it is bound to deteriorate a little if stored.

Once the ink is ready, place the plate on the heat-box and heat it until it is just too hot to touch. Once it has reached the required heat, slide it off the heat-box on to the jigger and force ink into all the etched areas with a leather-covered roller and a dabber. It may be necessary to force the ink into the deepest lines with your fingers, but if you do this wash them immediately or everything will soon become blackened. When the roller and dabber are not in use they can be safely stored in a saucer of oil. This not only stops the ink on them from drying but also helps preserve their leather coverings.

In filling all the cavities of the plate a great deal of ink will have found its way on to the unetched surfaces. This must now be carefully wiped off. Use a piece of scrim that has been folded into a pad which

28

fits neatly into the palm of your hand. The plate should still be warm but it will have cooled down enough to handle. Balance the plate on the outstretched fingers of your left hand, rather in the way that a waiter would hold a tray of drinks, and wipe it with a gentle sweeping motion. On no account must it be rubbed or scrubbed as this is bound to remove ink from the etched lines. As you do this, you will have to turn the scrim a number of times in order to present a clean surface, and in the case of a large plate you will probably need several pieces of scrim. Once the scrim has done its job most of the unwanted ink will have been removed, but there are likely to be a few traces left on the surface of the plate. Remove these last traces by hand wiping: the easiest method I know is to once again balance the plate on the fingers of your hand, and dip the side of your right hand in french chalk. Then gently brush the plate with the chalky edge of your right hand. This should pick up the last traces of unwanted ink.

And finally, the bevelled edges of the plate will have picked up some ink and will therefore need cleaning. This is easily done with a piece of scrim and a little gentle rubbing. Once all the excess ink has been removed the plate is ready for printing.

Printing

Place a piece of tissue paper at least the size of the plate on the bed of the press. This will prevent any dirt or ink that might have been left on the back of the plate from making a mess of the bed. Then place the plate, inked surface upwards, over the tissue paper on the bed of the press. The plate should be positioned in the centre of the bed with its longest edge parallel with the rollers to ensure maximum pressure at all times during the printing. Once the plate is in position it is ready for the paper, but before the paper is laid over the plate it must be briskly rubbed with a sponge to raise the nap. After the paper has been laid over the plate, put the blankets in position. Place the two fronting blankets in contact with the paper and the thick felt blanket on top of them. In order to prevent the blankets from absorbing too much moisture, insert a piece of blotting paper between them and the paper. This will help to stop the blankets becoming too wet. The bed can now be run between the rollers in one continuous movement. If the bed is stopped while the plate is between the rollers a dark line will appear on the print. It is therefore imperative to keep the rollers moving all the time.

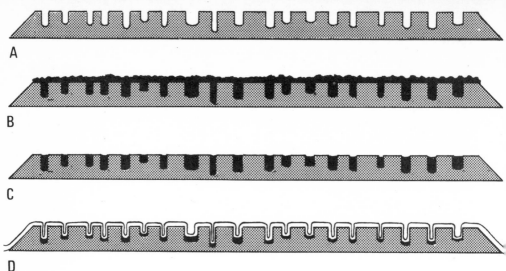

A

B

C

D

Diagram showing cross sections:
a) grooves of etched plate; b) plate and grooves filled with ink; c) clean plate with ink in grooves; d) paper pressed into grooves to pick up ink

We have now reached the climax of the operations. Remove the blankets, fold them carefully and put them back on their shelf. The paper can then be peeled slowly from the plate, revealing, we hope, a superb print. If the paper sticks to the plate it means that the ink was too thick. If, on the other hand, there are areas of unprinted paper, it means that either the paper was not soaked enough, or was too wet, or that the pressure of the press was too light. Apart from these obvious mistakes very little can go wrong in the printing.

Drying the prints

Once you have a satisfactory print it must, of course, be dried before it is stored or hung. There are two ways of doing this. The print can be fixed to a flat surface, such as a piece of hardboard or a wall with brown sticky paper holding it at the edges, and left in this state to dry. The print will shrink a little as it dries, and the sticky paper will hold it in position so that it does not cockle. Once dry it can be carefully cut from the board with a razor blade or sharp knife. As this method causes the paper to stretch, some of the relief of the print will be lost while it is drying, therefore, this method is really only useful for experimental proofs. For finished editions it is best to dry the prints in two stages. First stack the prints one on top of the other and leave them until the ink has dried. This will take at least twenty-four hours

for black inks, but considerably less for coloured ones. While the ink is drying the paper will also be drying and cockling. Once the ink is dry therefore, re-soak the paper and leave it between sheets of blotting paper under a heavy weight such as a sheet of thick glass to dry, changing the blotting paper as it becomes saturated. The weight of the glass should be just enough to stop the paper cockling but not enough to flatten the relief. Once dry the print is ready for storing or hanging. If the prints are to be stored they should be laid flat in a box or folio with a sheet of tissue paper between each one. They should never be rolled up, as this can harm the dry ink and will certainly distort the relief surface.

Improving the plate

One of the great joys in etching is that a plate can be re-worked over and over again. In this way an etching becomes almost an organic thing, growing and developing as your original idea re-shapes itself.

For this re-working the only essential tool is a 'scraper–burnisher'. This is a double-headed tool with a flat metal head for burnishing or polishing the surface of the plate at one end and a triangular pointed head at the other end which is used for scraping the plate. This tool is indispensable and you will use it frequently. It should therefore be looked after with loving care: never leave it lying about and above all never use it to agitate the plate while it is in the acid.

The scraper can be used for removing any unwanted lines. Scrape them with regular strokes from all directions so all that is left is a shallow dip in the plate. Then use the burnisher to polish the depression until it is really smooth. For this you will need a drop or two of light oil. Even though the removal of a line will leave a depression in the plate it should not hold ink when the plate is wiped. If, however, the lines to be erased have been etched very deeply, the work of the scraper may leave a cavity that is so deep that it will hold ink. This state of affairs is, however, easily remedied. Simply level the cavity with the surface by hitting it from behind with a hammer. This will obviously leave a hole in the back of the plate which, if left, might give way under the pressure of the press. It must therefore be filled. The best material for filling such a cavity is a piece of thick card that can be cut to size and stuck into the cavity. Occasionally the lines to be removed are so deeply etched that the plate will be scraped and burnished right through. This might produce very interesting results

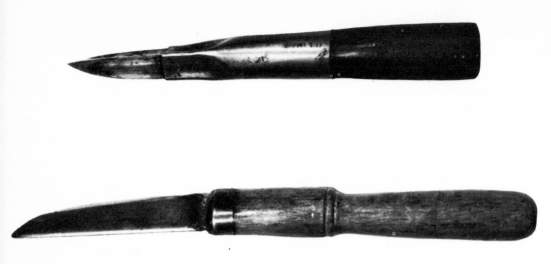

The scraper-burnisher is used for removing unwanted lines

when printed, but if a hole is made in the plate in this way, file its edges to a forty-five degree bevel in exactly the same way as you have filed the edges of the plate. If, on the other hand, the plate has been burnished right through by accident it can still be saved by the careful use of a little solder. Fill the holes with solder and then scrape and burnish it flat once again.

Areas that have been scraped and burnished a lot never print the pure white of an untouched area of plate. The result is rather an uneven and slightly greyish area of printing that can be as interesting if not more so than an area of plain white.

If you decide that all the lines on the plate are necessary and that still more lines are needed, the plate must be re-grounded. Do this in exactly the same way as you did the original grounding, and the plate is ready for as many new lines as are necessary.

Lines that are not as deep as you would like them to be present more of a problem. It is possible to re-ground the plate and to draw along the existing etched furrows, but this usually leaves deposits of ground behind that cause uneven biting. There are also various techniques for offsetting a ground on to a plate in such a manner as to leave existing lines free for biting but they are all extremely difficult to do and none of them is very satisfactory. It is far better to watch carefully during the original biting making sure that all the lines are bitten as deeply as is needed in one go.

As I mentioned above, any amount of re-working of a plate is possible, and it is never a good idea to abandon a plate until it has been worked almost right away. Even then it can often be carried on to further stages with the help of a little solder.

4 Some other ways of making a plate

Although there are more ways of putting an image on a metal plate that will hold ink than anyone could hope to put into one book, there are certain tried and tested techniques that are a basic part of the etcher's armament. Without them his work would be very limited. Below are some of these techniques, each of which can be used by itself or in conjunction with any of the others. It is in fact rare today to find prints that do not incorporate at least two of these techniques.

Sugar lift aquatint

This technique allows the artist to draw directly on to the plate in tone in such a way that the black marks that he makes on the plate will print as black marks on paper. This obviously does away with the problem encountered by all beginners in etching, of conceiving of a print made up of black marks that have to be drawn into a plate as light marks. The drawing is done with a solution known as a sugar-lift solution. To make this solution, dissolve sugar in a little water until the water is saturated with it and no more will dissolve. Next, mix india ink with this solution in equal parts. With this solution a drawing can be made directly on to an ungrounded but polished and grease-free plate. When the drawing is finished, leave it to dry. The solution will never become bone dry, but should reach a sticky thick texture. Once the drawing has reached this stage, cover the whole of the surface of the plate with a layer of asphaltum and turpentine mixed in equal parts. The asphaltum must be applied both gently and quickly in order not to disturb the drawing, and it is best applied with a large soft brush that is fairly dripping with the mixture. Once the plate is covered with asphaltum, dry it over a very gentle heat. When the asphaltum is dry, submerge the plate in water. This will cause the sugar-

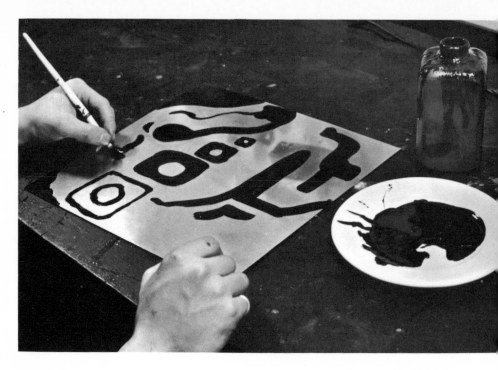

A plate being made by drawing directly with stop-out—producing a reversed image

lift solution to expand and crack off the plate, leaving the asphaltum stop-out intact everywhere except where the drawing was made. If the sugar-lift solution does not lift from the plate when it is put into water you can help the process along by putting the plate in warm water. This may, however, harm the asphaltum stop-out and should therefore be done only if all else fails. Once all the sugar solution has lifted the plate is ready for biting. Remember, of course, that its back and sides will need to be stopped-out before it is put into the acid. Once the plate has been bitten you can clean, ink and print it as you would a simple etching.

Direct drawing with stop-out

This technique will produce prints that are somewhat similar in quality to those made by the sugar-lift method except that all the marks that are painted on to the plate will print as white areas, while the unpainted areas of the plate will print as open, bitten, mottled-grey tones. To achieve these effects simply paint directly on to a polished,

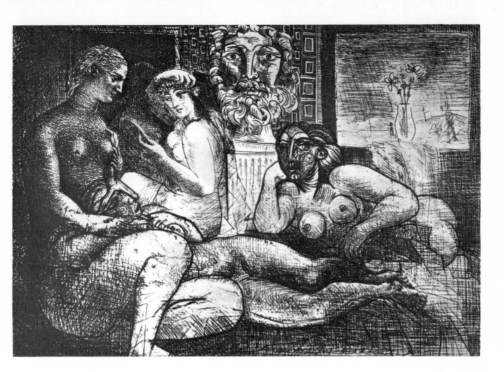

A fine etching by Picasso

grease-free plate with a stop-out solution made up of equal parts of asphaltum and turpentine. Once the stop-out has dried the back and sides of the plate can be stopped out and the plate can be bitten in the acid. As large areas of the plate are likely to be exposed to the acid, there will be much activity and bubbling in the bath with the accompanying yellow fumes. These fumes can be dangerous, for if they are inhaled they will damage the nostrils. Great care should therefore be taken when using this technique.

Only practice will tell you how long to leave a plate of this type in the acid, but as a beginning guide it is best to allow it to bite for only half as long as one would allow a plate that has been given a normal hard ground.

Many other types of ground can be substituted for those made of beeswax and those of asphaltum. For example, shellac mixed with methylated spirits makes a stop-out that will stand up to acid well. When drawn into with a sharp tool it splinters, producing shattered lines that can be very attractive. With experience and a minimum amount of chemical knowledge you will no doubt discover many new and exciting techniques.

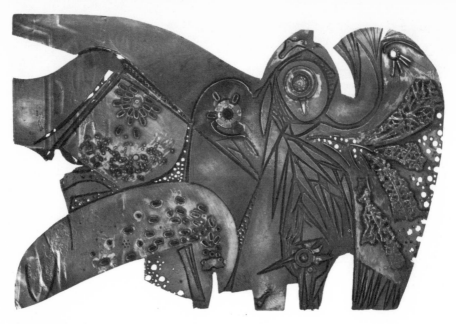

An example of a shaped plate

Shaping the plate

Yet another technique much favoured by modern etchers is that of either cutting the plate into expressive shapes or printing a number of plates at once to produce a complex print. For this all that is needed is a file and a pair of metal cutters. The plate can be cut with the metal cutters into any shape or number of shapes with the one proviso that all the resulting edges are filed down to a smooth forty-five degree bevel. If this is not done the paper will tear during printing.

Aquatint

The process of aquatint is integrally bound up with that of simple etching and it is rare indeed nowadays to find prints that do not incorporate both techniques. Aquatint is a process that enables the artist to produce a plate that will print areas of controllable tone ranging from light grey to black or the equivalent in colour. As an illustration of its versatility one has only to look at the prints of Goya, who used aquatint to create the most exquisite nuances of tone.

Aquatinting uses the acid in the same way as does simple etching but the ground used is different. The ground is simply resin which has good acid resistant qualities. Resin is dusted on to a plate and subsequently heated until the tiny specks melt. When these specks

A superb example of a Goya aquatint

cool they adhere to the plate. The plate is then bitten in the acid but only the spaces between the specks of resin are affected as the resin itself will not allow the acid to pass. This produces an area of tiny bitten holes. When this is inked and printed the result is an area of minute black dots rather like the tonal areas of a newspaper photograph. The depth of this tone is easily controlled by changing the depth of biting. Thus an area of aquatint that is bitten very deeply will print as deep black while an area bitten only very slightly will print as light grey.

Aquatint stage by stage

There are two methods of evenly distributing the resin over the plate, the bag and the box methods. The easier is the bag method: simply put the resin into a bag made of gauze or some other material whose weave is coarse enough to allow small pieces of resin to pass through. Shake the bag over the plate so that a fine layer of tiny particles of resin is deposited on the area that is to be aquatinted. The box method, on the other hand, calls for slightly more sophisticated equipment, but it allows a finer and more even layer of resin to be spread. The piece of equipment needed is called an 'aquatint box'. This is simply a large wooden box with a removable lid, a hole at the base of one of its sides, and supports running across its centre. Resin is put in the

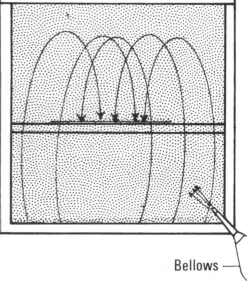

Bellows —

Aquatint applied to plate through gauze

Cross section of the construction of an aquatint box

bottom of the box and the plate is placed on the supports half way up with the surface to be aquatinted facing the top. The top is then replaced and bellows or the outlet end of a vacuum cleaner is then attached to the hole at the box's base. When the bellows are worked a sand storm effect is created within the box, and the resin is blown around in clouds. When the bellows are stopped the resin floats gently back down, some of it settling in a fine layer on the plate. The advantage of using a box as opposed to a bag is that the resin deposited is much finer and tends to spread much more evenly. If, however, you wish for a strong, coarse effect, a bag will obviously do the job much better.

Once the resin has been deposited on the plate it must be stuck there by heating. The heat must be carefully regulated and so a heat-box is not the best piece of equipment to use. A gas jet or the type of gas lighter that is joined at the side of most kitchen stoves is the best tool

for the job. Pass the lighted jet to and fro across the underside of the plate until the resin begins to melt. You can safely hold the plate in your hand while you are doing this as the amount of heat required to melt the resin is not very great. Heat the resin just enough to stick it to the plate; as soon as you see it is beginning to melt, remove the gas jet. If the resin is overheated it will run together and make a complete film of acid resistant ground, thus ruining the aquatint effect.

Once the resin has been stuck to the plate you can decide which are the areas to be aquatinted and proceed to isolate them. This is done by painting out all the rest of the surface with stop-out made from asphaltum and turpentine. Do not use a stop-out of methylated spirits as this is likely to affect the resin. Before finally biting the plate its back and sides will need stopping in the usual way. Once this has been done the plate can be put into the acid and bitten. The depth of the biting will correspond exactly to the depth of tone printed. Deep biting will therefore produce black printing whilst shallow biting will print as light grey. While the plate is being bitten the reaction between the plate and the acid will produce a mass of tiny bubbles. Brush these away with a feather as they appear. This must be done very gently, however, as the slightest pressure on the particles of resin is likely to dislodge them. Once bitten, the plate can be inked and printed in the usual way. Remove the particles of resin from the plate by rubbing it with a cloth soaked in methylated spirits.

Aquatint is usually used as a means of making hard-edged areas of tone but there are several ways of graduating this tone. Perhaps the easiest and most successful way of graduating aquatint is to scrape and burnish it. In this way you can scrape and burnish the aquatint right down to get the lightest tones, and leave it intact to get the darkest tones, and the range of greys in between can be achieved with careful use of the burnisher.

Some etchers prefer to achieve gradations of tone by pouring acid and water directly on to the plate. After the resin has been stuck and the rest of the plate has been stopped-out, pour water along the edge of the area to be aquatinted. Over the rest of this area pour dilute acid. At the edges the acid and water will mix causing a weak solution that will bite slowly into the metal. In this way the edges of the aquatint area will be bitten less deeply than the middle, which has had the acid poured directly on to it. The result, when printed, should be an area of aquatint whose edges gradually fade into whiteness. This is all that

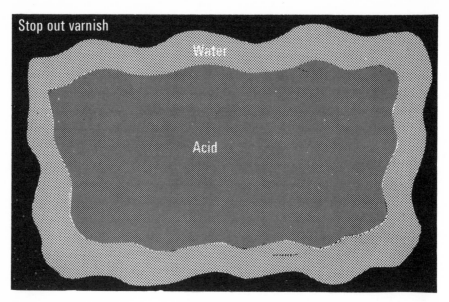

Diagram showing aquatint being bitten by water and acid to produce softened edges

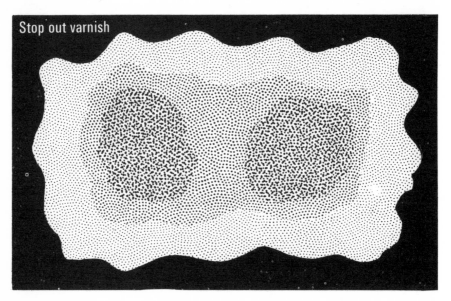

Diagram showing different tones produced by varied amounts of resin

will happen, however, and it is a method that is difficult to control. Using acid away from the acid bath also seems to me an invitation to accidents. If you do decide to work in this way, however, remember to work at a sink with the tap running all the time so that any spilt acid will be washed harmlessly away.

Yet another way of grading aquatint is to shake different sized particles of resin on to different areas of the plate. By doing this the areas of the plate covered with large particles of resin should print as a less dense tone than these areas spread with small particles. Different effects can also be achieved by brushing or pushing the resin around with your fingers before it is heated.

All of these methods allow for interesting and sometimes exciting effects but none is so simple and easy to control as the first mentioned —that of simply scraping and burnishing areas of uniformly-bitten aquatint.

If an area of very dense dark tone is required it is helpful to add another stage to that of aquatinting. This is to open bite the area before aquatinting it. To do this, the back, sides and surface of the plate must be painted out with stop-out, leaving only the area to be aquatinted. When the stop-out is dry place the plate in the acid for a short time. Then completely clean and polish the plate. You can now treat it with resin in exactly the same way as you would for straightforward aquatinting. The printed result of open biting an area before aquatinting it is an area of exceptionally deep tone, since this method ensures that as much ink as possible is held in the aquatinted area when the plate is wiped.

Aquatint Resin

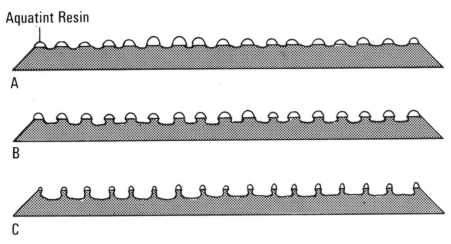

A

B

C

Diagram showing different depths of aquatint biting

5 Engraving and Mezzotint

We now come to the techniques of intaglio printing that are not strictly speaking etching, as they require no acid. They are nevertheless an integral part of any etcher's repertoire, and can be used by themselves or mixed with each other or any of the previously explained techniques. They are *mezzotint, burin engraving* and *drypoint engraving*.

Mezzotint

This method of making a plate is closest in its final effect to a plate made by the aquatint process, but it can, if carefully used, achieve even subtler effects. It is a technique that demands much practice if it is to be properly mastered, but once mastered it is perhaps the most exciting of all. Unlike all the other techniques mentioned in this book, with the exception of drypoint engraving, it relies upon ink being held in a burr raised *above* the surface of the plate rather than in a cavity bitten or cut into it.

The plate must first be scoured with a 'rocker arm' to raise an even burr all over it. If a rectangular plate in this state were inked and printed it would print as a uniformly black rectangular image. All forms and lines must therefore be scraped and burnished into the burred plate. In this way tones ranging from black to white can be created. The white tones are made by scraping off all the burr and polishing the surface of the plate flat again, and the black tones appear wherever the burr is left intact.

To raise the original burr you will need a 'rocker arm', a small tool that has a flat crescent-shaped blade with a serrated edge. It is rather like a small version of the tool used by gardeners for cutting the edges of lawns. The blade is attached to a wooden handle which is in turn

attached to a long strip of wood. At the end of the strip of wood is a wooden ball which fits into a grooved strip of wood that is set on a stand. The handle of the rocker arm is held in the right hand with its arm passing under the right armpit and resting in the grooved stand. The blade is then rocked gently backwards and forwards across the plate raising as it goes an even burr. You can carry out this operation using the blade only, but with the arm and stand an even burr is ensured. Once the plate is evenly burred all over it is ready for scraping and burnishing. If you decide that an area that has been scraped needs after all to print as tone, you can easily re-burr it by using a 'roulette'. A roulette is a small wheel with a serrated edge that is rolled over the area to be given tone, raising an even burr similar to that produced with the rocker arm. The roulette incidentally, is also useful for restoring areas of aquatint.

As this technique relies upon ink being held in a fragile burr rather than in a cut it is important to select a hard metal for the job. Zinc is a relatively soft metal and a burr made on its surface would break down almost immediately under the pressure of the press. Copper is fairly well suited to mezzotint, but the hardest and therefore the best metal for the job is iron. Even when using iron, however, the plate may need to be sent away for 'steel facing'. This is a process in which the plate is electronically faced with a thin layer of steel that follows exactly every mark that has been made on the plate. Once a plate has been steel faced it will stand up to almost any pressure and will last

The burr produced by working with a roulette

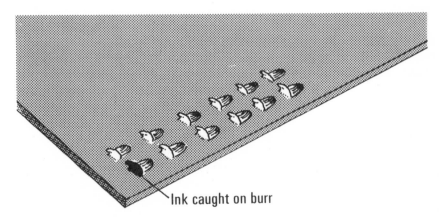

Ink caught on burr

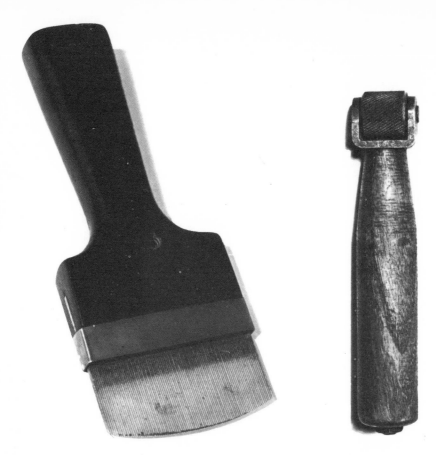

Aquatint rocker blade and a roulette used for making a mezzotint tone

through the printing of an edition of many thousands.

When the image has been satisfactorily made and all the scraping and burnishing has been done the plate must be carefully filed at the edges to a forty-five degree bevel. This done, the plate can be inked, wiped and printed exactly as one would a simple etching. When wiping, take care to do so very gently so as not to disturb the fragile burr. In the case of a steel faced plate this degree of care is obviously not necessary.

With care and practice an enormous range of tones can be created using the mezzotint process. As an illustration of its versatility one has only to look at the prints made as reproductions of the paintings of great masters during the last century in which the surfaces of plates were made to exactly reproduce all the nuances of the painter's palette.

44

Burin engraving

The earliest recorded burin engraving was made in 1446, and it is probably the oldest existing form of intaglio printing. It is a technique that reached great heights in the hands of artists such as Dürer, Bresdin and Rembrandt, and it is still being used today, not only by fine art print-makers, but also by the majority of industries that make the world's bank notes.

The single tool with which the engraver creates a whole world of lines and tones is his 'burin'. The burin is a small tool with a tempered steel shaft rather like a small, square chisel in shape. The steel shaft is usually about seven inches long and is square in cross section. One end is cut off at a forty-five degree angle to form the cutting edge while the other end is slightly bent to meet a rounded wooden handle that fits neatly into the palm of the hand. The burin blunts fairly rapidly with use and must therefore be sharpened frequently. Sharpening the burin is a difficult job to master, but with care and attention to detail it is not impossible. Two stones are needed: a carborundum stone for grinding, and an arkansas stone for finishing. To begin, hold the two underside surfaces of the cutting edge flat against the carborundum stone and rub them up and down in turn until they are sharp. Finish them on the arkansas stone, holding them in exactly the same position. Next, hold the burin as if it were a pen, with the flat end of the cutting edge pressed flat against the carborundum stone. Rub it with a circular motion until both cutting edges are perfectly sharpened. Once again, finish it on the arkansas stone. At each stage of the process the stones will need lubrication with a little light oil. The sharpening process is a very difficult job to master and the burin can easily be ruined. It is therefore advisable to try to persuade a master engraver to give you a practical demonstration before you try to do it yourself.

In a burin engraving all lines are incised into the plate with the burin and all tones are achieved by either cross-hatching or stipling. When cutting lines into the metal the most important rule to remember is that the plate must move, rather than the hand or the burin. Therefore, if a circle is being drawn into the plate, the plate is turned a full hundred and eighty degrees, while the hand is held steady and the burin continues cutting in the same direction. This not only ensures that the sharp burin is never cutting towards the body, thus

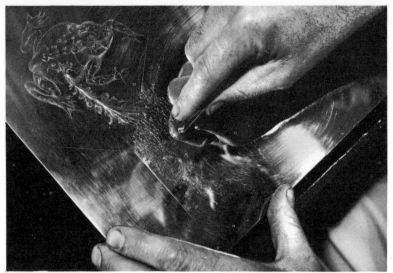

The burin in use

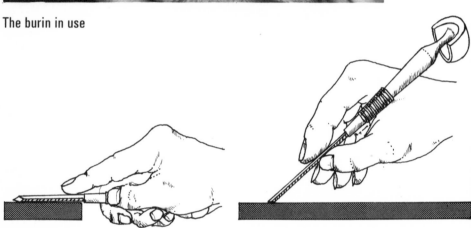

Sharpening the burin

avoiding the likelihood of accidents, but also that the burin can be controlled at a steady pressure. If the burin were to change direction it would almost certainly follow that its pressure would also change, making the depth of the incision uneven. The result would be an uneven printed line. In order to facilitate movement of the plate it must be worked at on a slippery surface. It is traditional for the engraver to work on a leather bag filled with sand, but a shiny table top or even a table with a blanket stretched across it will do just as well. As with etching, the depth and width of the incised line will govern the depth of tone and the width of the printed line. A line

that is cut deeply into the plate and which is very wide will print as a wide black line, whereas a narrowly-cut shallow line will print as a fine grey line.

Copper is probably the best metal to select for burin engraving, as the softness of zinc and the hardness of iron make control of the cutting difficult. Lines cut into copper are extremely difficult to see, so in order to avoid mistakes and eye strain it is helpful to discolour the plate before you start work. The usual method of doing this is to immerse the plate in a bath of dilute acid for a very few seconds. Immerse the plate just long enough to remove the shine from it, not for so long that it becomes pitted. Wash the plate thoroughly afterwards. The acid should dull the surface of the plate just enough to make any incised lines show up and sparkle.

Once all the cutting is finished, polish the plate thoroughly with a little ordinary metal polish and file down its edges to a forty-five degree bevel. Once this is done the plate can be inked and printed in exactly the same way as one would ink and print a simple etching.

Drypoint engraving

With burin engraving the lines are cut into a metal plate, but with drypoint the lines are only scratched enough to raise a burr above the surface of the plate that will hold ink. The burr is raised with a 'drypoint needle' which is usually a simple steel needle set into a steel shaft, although some are made of steel shafts holding sapphire or diamond tips. Hold the needle in much the same way as you would hold a pen and draw it across the plate to raise a scratched burr. In this case the quality of the printed line depends upon the amount of burr that is raised, which in turn is controlled by the angle at which the needle is held. If the needle is held upright it will only raise a slight burr which will print as a very fine line. On the other hand the needle held at a very low angle will raise a very large burr which will hold a lot of ink and print as a thick line. The lines made with a drypoint needle print with an attractive feathery quality which, compared with burin engraved lines, are rather like comparing a soft pencil line with a pen line. Many interesting effects can be achieved by mixing this technique with burin engraving.

As the burr that is raised is somewhat fragile it is best to choose a hard metal for the job. Copper can be used but iron is better. Zinc,

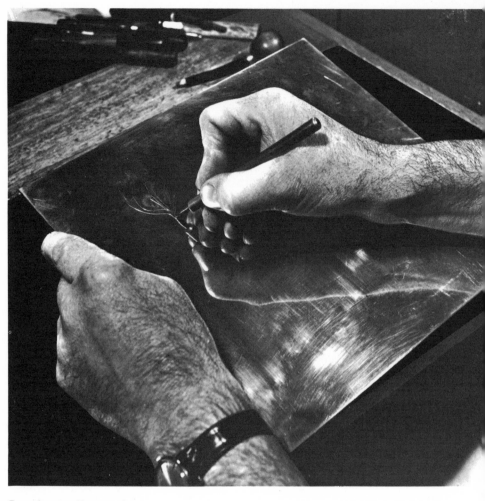

Drypoint needle in action

on the other hand, is much too soft and would give way under the pressure of the press. Like mezzotint plates, these copper and iron plates may need to be sent away for steel facing.

As with the other types of engraving, the plate, when finished, must have its edges filed down to a forty-five degree bevel. It can then be inked and printed in exactly the same way as a simple etching.

6 Two alternative ways of taking a proof

If, as is probably the case, a press is not immediately available, two methods of taking a proof can be used, neither of which call for the use of a press. One of these methods will produce an image similar to that of a plate printed in a press; the other will produce a print in which the tones and images are reversed. They are (1) a plaster proof and (2) a surface print.

Taking a plaster proof

Although this method is somewhat laborious it is the best way so far discovered of replacing the press. The plate is inked and wiped in exactly the same way as one would for normal press printing and then laid face upwards on a piece of thick glass, formica or similar smooth surface. Walls about one and a half inches high are then erected around the plate at a distance of at least half an inch. These walls can be made of either Plasticine or of four strips of wood nailed together. Plaster of the type that dentists use is then mixed with water until it is of a creamy texture and is beginning to heat up. In order to prevent the plaster becoming lumpy always sprinkle the plaster over the water and never add water to plaster as one would mix cement. It is best to mix the plaster in a soft plastic bowl that is flexible. This makes cleaning much easier as the plaster will stick to the edges of the bowl. A soft bowl can be bent out of shape which will force the plaster to split from its sides. When the plaster has been mixed to the required consistency gently pour it over the plate to a depth of three-quarters of an inch and then leave it to dry and cool. When it is dry and completely cool the sheet of set plaster can be gently lifted from the plate. If the plaster sticks to the plate, you can easily remove it by running a knife around its edges. The result will be a perfect print

in relief on the plaster that will not only exactly resemble a paper print but that will be attractive enough to be framed and shown as a work in its own right. Very often the solidity of a plaster proof can be a great deal more impressive than a simple paper print. Another advantage of this method is that, unlike the surface print, it can be used successfully with drypoint engravings and mezzotints.

A surface print

To make a surface print, spread ink thinly on the inking slab with a knife and roll it out with a hard rubber roller. It is best to use a roller whose width is at least as wide as the plate. Once the roller has picked up a thin layer of ink, roll it evenly over the plate. The surface areas of the plate will pick up the ink from the roller. Care must be taken not to spread the ink too thickly, or the cavities of the plate will fill with ink and ruin the print. The ink must therefore be rolled out very evenly and thinly on the inking slab before it is used. Once you have inked the plate in this way, unsoaked paper can be laid over it and the two can be pressed in a lino printing press or under a pile of heavy books to which you can add your own weight.

This method of taking a proof will not give perfect results and large areas of tone may print unevenly, but it will at least give you some indication of the state of the plate. Perhaps an even better way of taking a print from a plate inked in this manner is to use an offset method. Once the plate has been inked as above, a large rubber roller, whose width is at least that of the plate and whose diameter is also at least as large as the length of the plate, is rolled heavily over it once. Having picked up the ink from the plate, it is then rolled over a piece of unsoaked paper and the image is reproduced exactly as it was on the plate. This method of offset printing will produce fairly good results but it has two major disadvantages. First, it will print an image which is not reversed in shape but which is reversed in tone. The result being that all the areas that would normally be left as blank white paper will now be inked and all the lines will be left blank. Any images that have been drawn in reverse will also print in reverse (see section on drawing on a grounded plate). Secondly, rollers of sufficient size are not only difficult to find but are also very expensive.

Both of the above methods of taking a surface print can only be used with etched, aquatinted or engraved plates.

7 Colour printing

It is probable that after some experience with black and white printing you will want to try your hand at colour printing. In this field there is yet much to be discovered.

As the inks used in colour printing are transparent they can be overlapped to produce whole ranges of secondary colours. In fact, theoretically it should be possible to produce prints incorporating all colours using only three inks, red, blue and green. It is however difficult to design for this kind of colour printing. The best way of doing this is with the aid of transparent coloured tissue paper. The tissue paper can be cut to shape and stuck over a black and white print to give some indication of the effect of the colours. It is best to use glues that are not water based as most tissue papers tend to run when they come into contact with water. Subsequent layers of tissue will help you to work out the effect of printing layers of colour. This type of working model will obviously not reproduce a coloured etching but it will give some idea of possible colour mixtures. In this way it is possible to work out how to achieve the maximum colour range with the minimum number of plates.

Having decided upon the colours to be used there are three ways of printing to be chosen from: the separate plate method, the single plate method and the offset method.

The separate plate method

This is perhaps the easiest method of producing a colour print. Separate plates are made and inked for different colours. Although in theory a whole spectrum can be made with only three plates, in practice this will only produce a rather garish result. It is better to stick to only a few colours based on no more than two primaries.

The basic idea behind this technique is to print a series of plates on to one sheet of paper with each new plate fitting exactly into the print made by the preceding one. This does, however, cause two major difficulties. First is the difficulty of accurately registering the plate on to the paper, and secondly the difficulty of drawing on each plate in exactly the right place. The best method I know of for transferring the image from one plate to the other is as follows. First make a print on to a piece of paper. When this has been done, lay the new plate over the print while it is still wet and run the two through the press. This will offset the image from the paper to the new plate. The new plate can now be worked on with whatever technique is desired. If, however, the new plate is to be etched through a ground, the ground will have to be laid before the plate is run through the press with the preceding print. Before the new plate is bitten, all traces of ink from the print must be removed so that they do not interfere with even biting. The inks you will need are sold in most art shops as 'copperplate inks' and are used in much the same way as black ink. It is easier, however, to ink the plate with a piece of scrim rather than with a dabber and the plate should not be heated while inking or wiping. The inks can be thinned with either light oil or with 'copperplate medium', both of which are sold in most art shops.

The printing and registration of one image on to the other can be done either as a number of separate operations or as one continuous one. The continuous process is the one that usually gives most certainty of accurate registration. In this process the first coloured plate is printed normally except that the bed of the press is stopped just before the paper and blankets have completely come through the rollers. In this way the paper is caught under the rollers and held in position. The blankets and paper are then folded carefully back and the position of the plate is marked either by chalking around it or, for even more accuracy, two strips of heavy metal can be placed around it. The next plate is now inked and slid into position up against the strips of metal. The paper and blankets are then folded back in position over the plate and the three are rolled through the press. If the print is to have more colours this technique of catching the paper under the rollers can be repeated as many times as is necessary. Printing in this way does, however, present one complication. Because the inks are oil based they will not take on top of each other when wet unless the underneath one is less oily than the one on top. This means

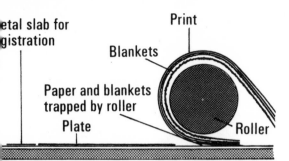

metal slab for registration

Print

Blankets

Paper and blankets trapped by roller

Plate

Roller

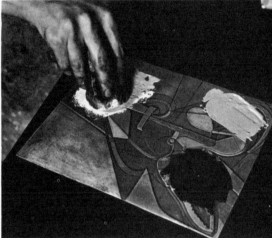

1 Print and blankets held by the rollers
2 Print and blankets laid over second plate
3 A plate inked in different colours

The other method of printing from a number of plates takes a little longer but it does away with the problem of inks not taking on one another. The first plate is inked and printed in the normal way and the print is left to dry for at least twenty-four hours. Once the ink of the print is dry it is re-soaked and the next plate is inked. The print is then laid face upwards on one of the facing blankets on the bed of the press and the plate is put in position on the print. The other blankets are then put on top of the plate, facing blanket first, and the bed is run through the rollers. This method ensures that the inks take on top of each other and makes registration easier. It has one drawback, however: putting the plate on top of a blanket may make it warp.

53

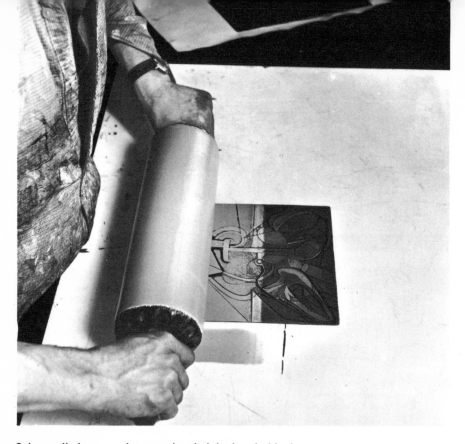

Colour rolled over a plate previously inked up in black

The surface method

This is done in exactly the same way as the surface print described on page 50. If it is done using a press, however, the results should be very satisfactory. Superb results can be produced by mixing this surface technique with that of simple black and white etching. Ink and wipe the plate with ordinary black ink and prepare it completely for simple printing. When it is ready, roll it over with a coloured ink or roll areas with different colours. This is best done with a roller that is large enough to cover the coloured area with one sweep; if it is rolled twice the ink will build up and print unevenly. Pass the plate through the press with the paper and blankets in the usual position. The resulting print will be in colour with some of the black areas glowing behind screens of colour and others fusing with the coloured ink to form new tones. Although the results of this method are very dramatic they are almost unrepeatable, and can therefore only be used for single prints.

The use of colour is still new and much has yet to be learnt. Experiments have yet to be done in printing with both oil-based and water-based inks and producing transparent tones. The field is open for the beginner to find new and exciting techniques.

The single plate method

The single plate method limits the amount of colour overlapping that is possible but it can produce exciting results that make up for this limitation. The plate is inked in different areas with different colours and each area is wiped with a small piece of scrim. Then the plate is printed normally. The result will be a print made up of as many colours as were used on the plate. Some printers, using this method, can produce whole editions of exactly similar prints, but for the beginner it is really an experimental method of producing unique prints.

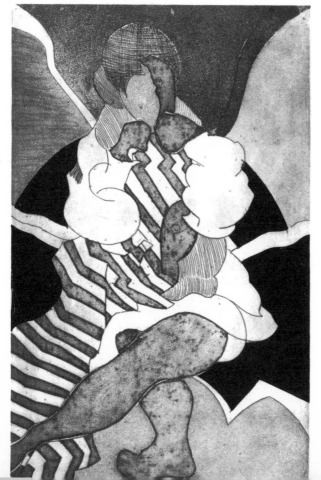

A modern abstract etching

8 Organisation of your studio

It is obvious that when working with heated oil-based inks and potentially dangerous acids it is very important to be well organised. Ease of access to materials and safety should be foremost in your mind. Wherever possible a table top should be set aside for each stage of the operations and all those processes that require water should be carried out near a sink. It is a good idea to make a diagram such as the one below allotting the space for each process that you are likely to use.

Almost certainly the ideal conditions envisaged in the above diagram will not be available and so in the following sections I shall point out the dangers that most need watching in each process.

ACIDS: When a metal plate comes into contact with acid the chemical reaction that takes place gives off dangerous fumes: nitric oxide in the case of nitric acid and chlorinous gases in the case of hydrochloric acid. Both of these types of gas are strong oxidising agents which will, if inhaled, attack and damage the nose and throat. Because of this danger some kind of ventilation is necessary for the acid baths. If the plate that is being bitten is small the amount of gas given off will also be small and can easily be dispelled if the biting is done under an open window. However, this is impractical in the winter and, for that matter, much of the summer too, as frostbite is as unpleasant as inhaling acid fumes! In addition to the weather factor the size of the plate must be taken into account. A large plate or one that is undergoing a lot of open biting will give off more fumes than can be coped with by the draught from an open window. In these cases some kind of extraction unit will have to be installed. There are a great many commercial firms that deal in laboratory equipment who will supply and install extraction units, but these are very expensive. Large expense is hardly warranted

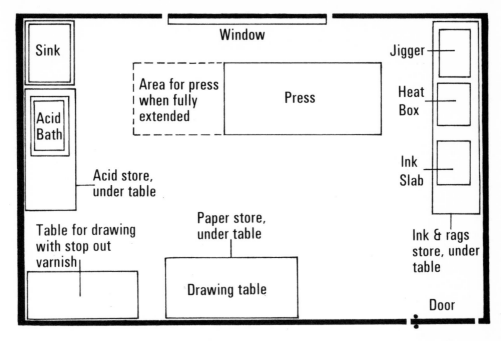

The ideal layout for your etching studio

for the amateur etcher who is probably only working in his spare time and on no great scale. The problem can be overcome by building your own very simple extraction unit. The skill and work necessary is not beyond any handy man or "do-it-yourself" devotee.

The Extraction Unit: The unit is made up of a simple extractor fan which can be bought fairly cheaply in most electrical shops, a large tin umbrella that is a little larger than the acid bath at its widest end (the trumpet from an old wind-up gramophone is ideal for the job) and some tubing that is wide enough to fit over the fan. Suspend the umbrella over the acid bath making sure that it is near enough to effectively intercept the rising fumes, but allowing room enough below it so that you can work on the plate while it is biting. The narrow end of the umbrella is joined to a length of large piping leading to a window. Cut a hole in one of the window panes and fit the extractor fan into it. Next, fit the tubing leading from the umbrella over the fan. When the fan is switched on it will suck the acid fumes through the tubing and out the window where they will be dispelled harmlessly. The distance from the acid bath to the fan should be as short as possible even if this means that the bath will have to be located at some distance from the sink. If this is the case, it is as well to invest

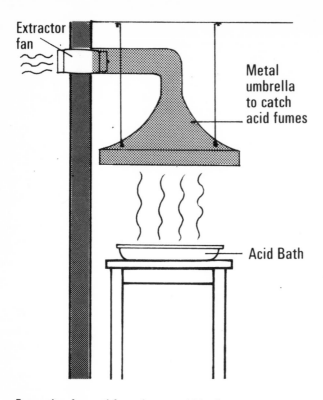

Extractor fan

Metal umbrella to catch acid fumes

Acid Bath

Extraction fan and funnel over acid bath

in a large bucket, or still better, a plastic dustbin that can be filled with water and used for rinsing the plate when it is removed from the acid. The water in the bucket will need changing frequently, as each time a plate is rinsed the acid content of the water will go up and therefore be more likely to eat away the sides of the bucket.

THE INKING SLAB: There is no need to locate this near the sink, but as the ink spreads a lot however fastidious you are, it is as well to keep it at the other end of the studio from the paper and press blankets. The table should be large enough to take the inking slab and the various tins and bottles of ink. A shelf fixed at easy reaching distance above the table, on which rollers, etc., can be stored, is also a great help. As the ink is bound to spread around the inking area it is a good idea to cover the table with some kind of material that is easily cleaned. There are many types of shiny table covering that can be bought cheaply in most hardware stores which simply unroll and stick to the table top.

THE HEAT-BOX AND JIGGER: For ease of access and the greatest efficiency the heat-box and jigger should be located next to the inking slab so that you do not have to walk around the room carrying rollers and dabbers full of ink. A batten can be fitted along the wall above the heat-box with hooks for the rollers and dabbers that are used for grounding. A shelf for the various types of ground is also a good idea. I have always found that it is easiest to work at a heat-box and jigger that is about three and a half feet from the floor but you will soon work out for yourself the right height for your own equipment. As you will be using a great deal of scrim it is useful to have a drawer in which large quantities of new scrim can be kept free of dust and ink.

DRAWING: Once again an area must be set aside for drawing and engraving. Again, a fairly large table top is ideal for this. The size of this area will obviously depend upon the size of the plates that you are likely to be making, but do not skimp on size. A table that inhibits movement will also inhibit your drawing, and the plates you produce will look as though they were made in cramped conditions. A drawer in the table can be used to keep the burins, drypoints and burnishers. Burins and burnishers are expensive and easily harmed, so look after them carefully and always clean them after use. Above all, *never* put them into the acid. When not in use they can be kept wrapped in an oily cloth. This will not only guard against corrosion but also protect their cutting edges.

STOPPING-OUT: Another area will have to be set aside for the stopping-out process. This must again be a flat surface with an easily cleaned, non-absorbent surface. If another table is being used it is best to locate it against an uncluttered wall so that plates that are covered with wet stop-out can be propped up and left to dry. Here also the turpentine and methylated spirits can be kept. As a great deal of both of these liquids will be used it is most practical to buy them in large quantities. The difference between the price of eight individual pints of turpentine and a gallon bought in bulk is quite staggering. Another part of the equipment that must not be skimped on is rags. The more old rags you have, the cleaner and therefore the safer everything will be. It is a good idea to buy in bulk from a rag and bone merchant or else to visit local jumble sales where for a few shillings you can come by enough old cloth to last a very long time.

THE PAPER: It is always best to keep the paper as far away from the inking and stop-out areas as possible. Store it flat between sheets of glass and blotting paper, preferably on yet another table top.

In arranging your workroom, try as far as is possible to see that each of the processes is contained in its own area. If they overlap, the least that can happen is the production of a dirty print and the worst can be acid burns and fire. With the cleaning of plates and hand wiping there is bound to be some dirtiness. It is therefore sensible to invest in some industrial barrier cream and cleanser. The type that is used in garages is ideal and will remove all traces of grease and ink from your hands. Once again it is much cheaper to buy these in large amounts.

9 Spilt acid

Acid that has been diluted ready for etching causes no real problems. In this state it burns very slowly and if spilt it can be wiped up with a wet sponge and no harm will be done. Undiluted acid, on the other hand, is extremely dangerous. If acid is spilt undiluted from the bottle it must be neutralised at once with water. If acid is spilt on clothing it should be washed off immediately with copious amounts of water and then, as an added precaution, it should be neutralised with either a strong solution of bicarbonate of soda or ammonia. Bicarbonate of soda is the best chemical to use, as ammonia is a bleaching agent and therefore likely to remove any dyes from the cloth. I have read many times of neutralising acid that has been spilt on the skin with such things as ammonia or soda but don't try it. Acid spilt on the skin will burn rapidly and should be washed off with water only. If a neutralising chemical is poured over the acid it will undoubtedly stop the acid burning but the reaction between the acid and the neutralising agent will generate enough heat to burn just as badly. I have also heard that the way to remedy the effects of breathing in nitric oxide is to drink a solution of water and bicarbonate of soda. Where this idea came from I don't know; all it is likely to do is to make you feel rather sick. If you accidentally breathe in large amounts of nitric oxide, a doctor should be called and you should move out into the fresh air. In fact, in the case of all accidents a doctor's advice is always much better than any number of home-made remedies.

In the above section I have perhaps over-stressed the dangers involved in using acids. It is surprising how resistant the human body is. Although acid will burn very badly if it is allowed to stay on the skin, prompt washing will ensure safety every time.

10 Improvisation

By now you are probably balking at the thought of all the complicated and expensive equipment you will need to begin etching. The equipment that I have so far described is what one would buy given unlimited resources. Much of it, however, can be improvised. One has only to think of the Whistler etchings made while the artist was touring Europe in the last century to realise what can be done with the absolute minimum of equipment. Practically every piece of equipment can be improvised and what can not is always available for use at your local art school.

The only pieces of equipment that should not be improvised are the acid bath and roller. I have seen plates etched by being placed on a sheet of glass and surrounded with walls of Plasticine into which the acid is poured. This method undoubtedly bites the plate efficiently but to use it is really casting caution to the winds and inviting accidents. The rollers and dabbers must be well made and well cared for because upon them rests the whole of the technique. Dirty or uneven rollers will lay an uneven ground that will cause uneven biting. These should therefore not be improvised or skimped on.

The rest of the equipment can be improvised perfectly well. The heat-box can be replaced by a kitchen stove and the jigger can be done away with completely or replaced with a simple wooden box. Aquatint boxes are a luxury; they are certainly not indispensable. A gauze bag will do just as well. Almost any pointed instrument that is hard enough to scratch the surface of a plate can be substituted for a mezzotint rocker arm but the use of such a substitute will entail a great deal of careful laborious work.

The beginner who decides initially to limit himself to engraving has a much easier task in terms of equipment. He needs no grounds, no acids and no stop-out. He can, in fact, engrave his plate almost

anywhere, since he needs only a burin, and can then take it at a convenient time to an art school studio for printing. He might even improvise on the press. It is a very difficult task to make an etching press but for a talented handy-man it is not impossible. All that is needed is an old-fashioned mangle with wooden rollers. A thick piece of wood can be put between the rollers to act as a bed and a thick sheet of foam rubber substituted for the blankets. This will not make a press that will give perfect results but it will at least allow you to take fairly satisfactory proofs. You will be able to tell what condition the plate is in at each stage. Then when you are finally satisfied with the finished plate it can be taken to a press for the printing of the finished edition.

When first cleaning the plate of grease and surface scratches, two pieces of improvised equipment are of great use. Firstly, a block of willow charcoal. Rub this briskly over the surface of the plate while it is wet, thereby removing a very fine layer of metal and with it any light scratches. Although this process will remove surface scratches, it leaves the plate with a slightly uneven surface, which, of course, has to be polished. If metal polish and a cloth prove ineffective for this job, a piece of ordinary corrugated card can be substituted for the cloth. The texture of the card is just abrasive enough to remove a fine layer of metal without leaving any scratches. If a slightly coarser area is to be polished, the addition of whiting (or still better jeweller's rouge) to the polish is very effective.

The inking and wiping of the plate can also be done with improvised equipment. The roller and dabber can be replaced with a wad of soft scrim, and the large amounts of scrim used for wiping off excess ink can be replaced by newspaper (cheaper newspapers are best as they are usually printed on more absorbent paper). Dab the ink onto the plate with the wad of scrim, taking care not to rub, as this would remove as much ink as was deposited. When all the etched areas are full of ink, remove the excess by rubbing gently with a piece of newspaper laid flat over the plate, with a circular motion. You will have to use many pieces of clean paper before the plate is absolutely clean; which takes time, but does at least save the cost of large amounts of scrim.

INDEX